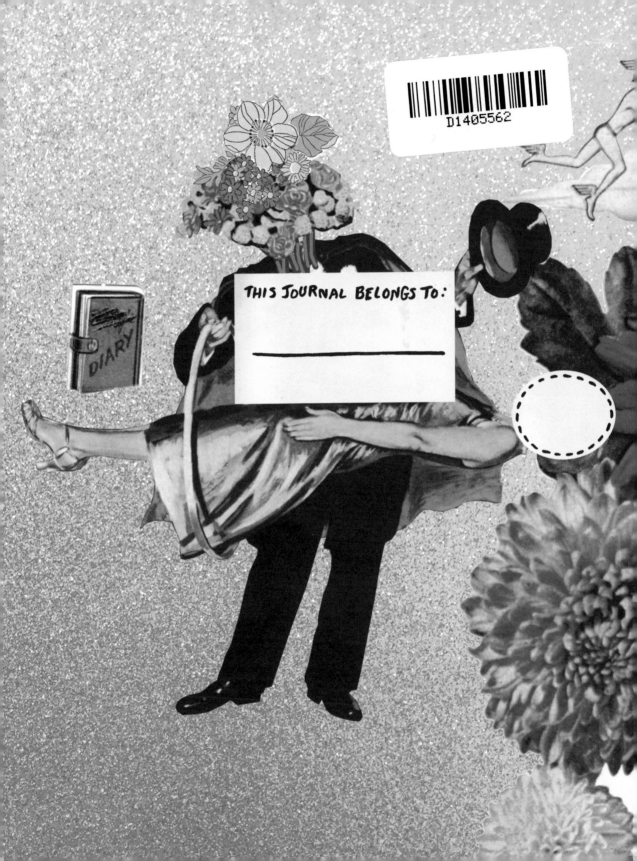

THIS JOURNAL BELONGS TO:

DIARY

crownpublishing.com
clarksonpotter.com

CLARKSON POTTER is a trademark and POTTER with colophon
is a registered trademark of Penguin Random House LLC.

Library of Congress Cataloging-in-Publication Data
is available upon request.

ISBN 978-0-553-49632-1

Printed in China

Book and cover design by Danielle Deschenes
Collages by Lise Sukhu
Additional collages by Jessie Bright (pages 16, 23,
31, 56, 66, 78); Danielle Deschenes (pages 1-3, 13, 14, 35,
71, 72); Debbie Glasserman (pages 7, 81, 89); Lauren Monchik
(pages 18, 25); Laura Palese (pages 28, 45, 53, 58, 80, 82);
Anna Thompson (pages 8, 51, 57)
Written by Emma Brodie

10 9 8 7 6 5 4 3 2 1

First Edition

INNER RAMBLINGS

A JOURNAL

Clarkson Potter/Publishers
New York

I liken my friendship

with _____
(NAME)

to _____ and _____
(condiment) (condiment's
 best friend)

because _____

(elaborate using
other fridge friends as you
see fit)

The piece of clothing I cannot do without right now is _____.

I got it from _____ and it's _____
(adj.)

and so very _____ and _____.
(color) (texture)

I can wear it whenever I _____.

In the larger sense, it reminds me of _____.

When I wear it I feel _____
(first thing you think of)

_____.

WHATEVER HAPPENED
TO THAT DECK OF CARDS
? ? ?

YOU KNOW, THE ONE YOU GOT ON A BARGE FROM THAT PROFESSIONAL
GAMBLER AFTER WINNING THAT GAME OF TEXAS HOLD 'EM?
(PLEASE DO REMIND US OF WHERE YOU WERE AND THE NAME OF
THE BOAT, AND THE COLOR OF THE SEQUINS YOU WERE
WEARING—MAKE IT UP IF YOU HAVE TO!)

THIS IS THE WRAPPER
FROM THE LAST PIECE OF
CANDY I ATE. IT WAS DELICIOUS.
ALSO, I WROTE THIS HAIKU ABOUT IT:

I DWELL IN POSSIBILITY

—EMILY DICKINSON

WHENEVER i HAVE A pRoBLEm
I Always GO TO MY FRIEND

SHE GIVES AMAZING ADVICE diKe

AnD soMETIMES SHE JUST listens, AnD THAT'S
PRetty GREAT Too.

IF YOU DON'T TAKE A RANDOM INSULT PERSONALLY, can you still take a random compliment personally?

MY TOP TEN SONGS TO BLAST ON REPEAT
(OKAY, LET'S BE SERIOUS, HAVE A DANCE PARTY TO):

10.

9.

8.

7.

6.

5.

4.

3.

2.

1.

Date: ___/___/___

Dear _____,

I've been meaning to tell you this
for the longest time and I always
forget so here it is.

Yours,

Right now, my favorite character from a movie
is _____ from _____.
Okay, I'm a little obsessed with _____
who plays her, but I also love, respect, and admire
said character (I would be her for a day if I could)
because _____

AND _____

ALSO _____

even though _____

I WOULD JUST BE HER, OKAY? GET OFF MY BACK.

1. Draw 3 squiggles. **2.** Then draw an outline around the squiggles. **3.** Then draw an outline around the outlines of the squiggles. **4.** Repeat until the outlines are touching.

 5. Color as you see fit.

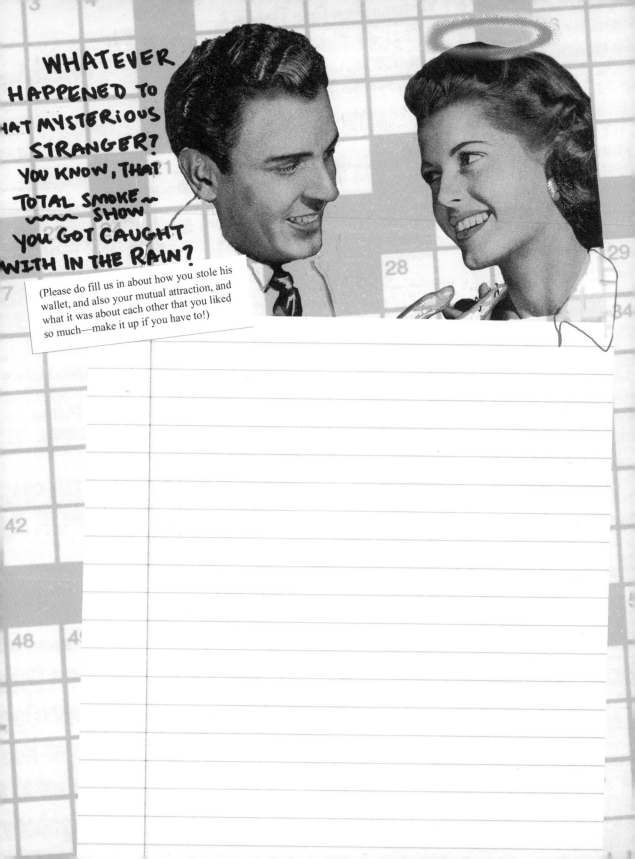

WHATEVER HAPPENED TO THAT MYSTERIOUS STRANGER? YOU KNOW, THAT TOTAL SMOKE~ ~~~ SHOW YOU GOT CAUGHT WITH IN THE RAIN?

(Please do fill us in about how you stole his wallet, and also your mutual attraction, and what it was about each other that you liked so much—make it up if you have to!)

" I AM in the MOOD

to dissolve into the sky."

—*Jacob's Room*, Virginia Woolf

HERE IS A LEAF I FOUND.
ITS MEDICINAL PURPOSES ARE:

1.

2.

3.

4.

MAKES ME LAUGH HARDER THAN ANYONE

ELSE BECAUSE... _____ ... _____ ...

... _____ ... _____ ...

AND ... _____ ... _____ ...

... _____ ... _____ ...

... _____ ... _____ ...

... _____ ... _____ ...

... _____ ... _____ ...

... _____ ... _____ ...

... _____ ... _____ ...

... _____ ... AND OKAY, FINE,

IT SOUNDS DUMB I GUESS YOU HAD TO BE THERE.

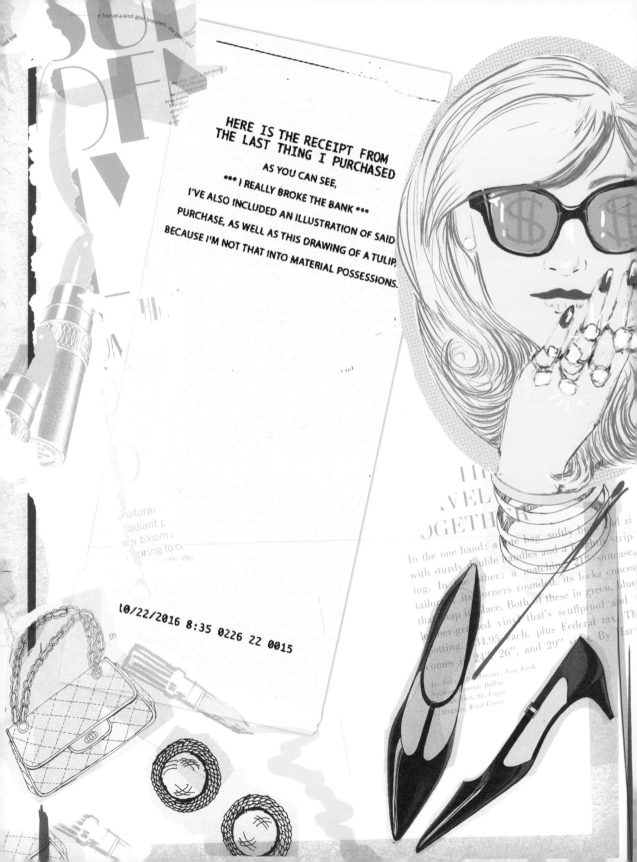

HERE IS THE RECEIPT FROM
THE LAST THING I PURCHASED

AS YOU CAN SEE,

*** I REALLY BROKE THE BANK ***

I'VE ALSO INCLUDED AN ILLUSTRATION OF SAID
PURCHASE, AS WELL AS THIS DRAWING OF A TULIP,
BECAUSE I'M NOT THAT INTO MATERIAL POSSESSIONS.

10/22/2016 8:35 0226 22 0015

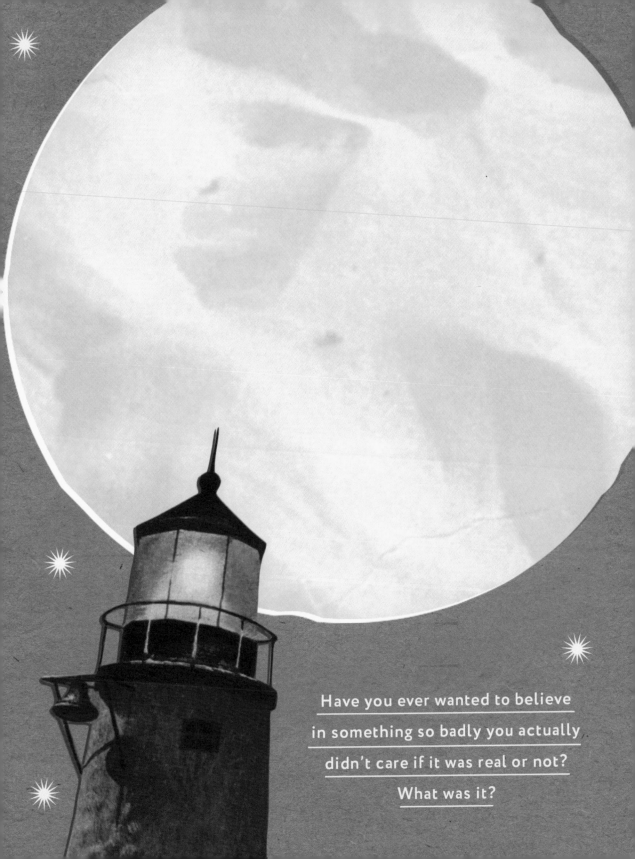

Have you ever wanted to believe in something so badly you actually didn't care if it was real or not? What was it?

SO I JUST MET _____.
DON'T QUOTE ME ON THIS, BUT
MY FIRST IMPRESSION IS...

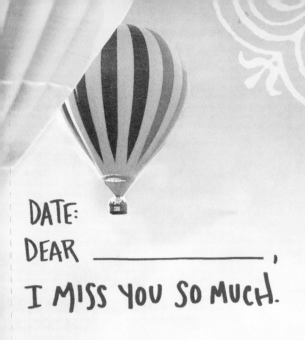

DATE:
DEAR _____,
I MISS YOU SO MUCH.

YOURS,

I really look up
to my friend:

I'm not 100% sure why she hangs out with me, but I'm not going to question it.

She's just so:

Here is a photo of me and

_____ and a

drawing of the frame it would be

in if we were _____
 (NATIONALITY)

_____ .
(TYPE OF RULER)

YOU NEVER DID FINISH TELLING THAT
STORY ABOUT THE TIME YOUR CAR
BROKE DOWN IN THE DESERT

(PLEASE DO REMIND US OF HOW YOU MANAGED TO STRETCH OUT
THAT ONE BOTTLE OF WATER, AND HOW YOU CAME BY THAT
LONGHORN SKULL, AND ALSO WHAT WAS IN YOUR TRUSTY FANNY
PACK THAT SAVED YOU—MAKE IT UP IF YOU HAVE TO!)

WELL . . .

4/4 THIS IS KIND OF EMBARRASSING, BUT RIGHT NOW I'M OBSESSED WITH THE SONG

I KNOW, I KNOW, EVERYONE LOVES IT, BUT

THEY DON'T LOVE IT LIKE I DO.

WHAT I MEAN BY THAT IS...

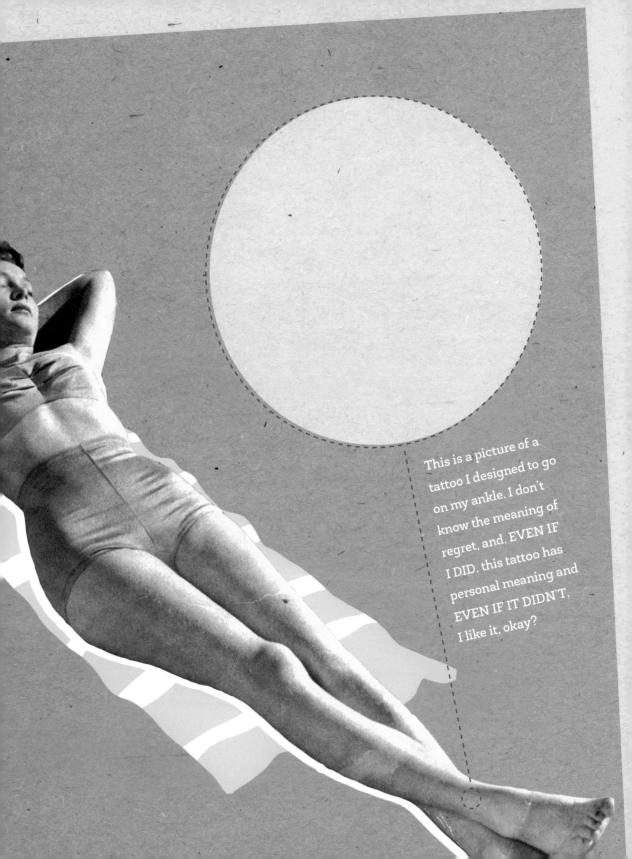

This is a picture of a tattoo I designed to go on my ankle. I don't know the meaning of regret, and, EVEN IF I DID, this tattoo has personal meaning and EVEN IF IT DIDN'T, I like it, okay?

HERE ARE 4 QUOTES I'm super into right now:

1.

2.

3.

4.

DATE:

DEAR _____,

YOU FILL MY HEART WITH SONG.

I'M SERIOUS. THIS IS THE SONG.

YOURS,

PEOPLE ARE ALWAYS GETTING ME CONFUSED WITH MY FRIEND _____. I DON'T REALLY KNOW WHY BECAUSE WE'RE SO DIFFERENT, BUT IF I HAD TO GUESS, IT WOULD BE BECAUSE...

I CANNOT GO A DAY
WITHOUT EATING ▓▓▓▓▓▓
SERIOUSLY, I CRAVE IT. WHAT?
IT FEEDS NOT JUST MY BODY, BUT
MY S O U L.

I LIKE IT BECAUSE...

Sorry

OOO Oooo oo. Oo. How did that story end where you were helping solve the mystery of who kidnapped that fancy man's cat?

(Please do remind us of the name of the cat, and how much he was insured for, and who DID take him, and also what kind of trench coat you were wearing—make it up if you have to!)

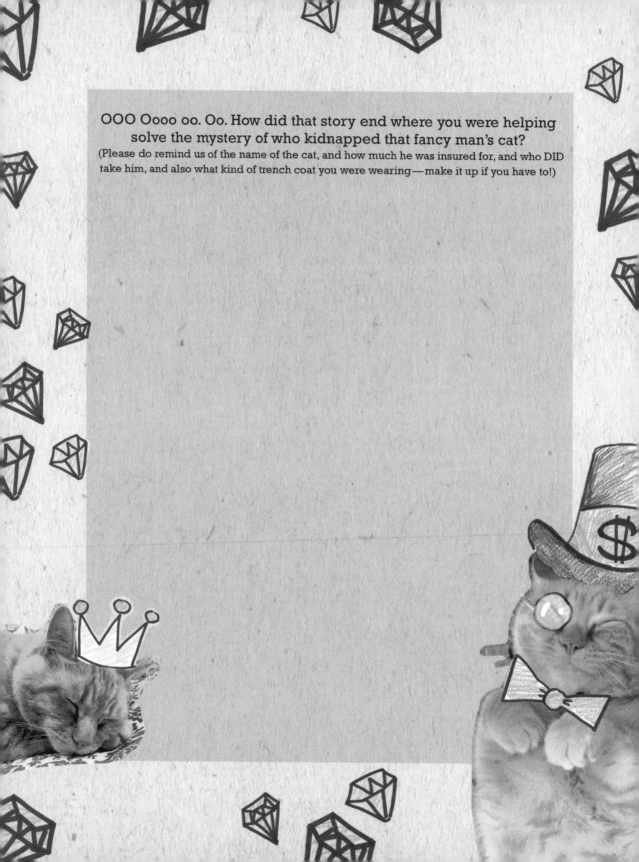

COOL,

—HERE IS—
THE MOST RECENT TICKET I BOUGHT.
AND A LIMERICK I WROTE ABOUT IT:

_____ TICKET

_____ THICKET

_____ BRAIN

_____ INSANE

_____ LICK IT.

"BE YOURSELF;
EVERYONE ELSE IS
ALREADY TAKEN."

— OSCAR WILDE

WHENEVER I'M SAD,

I GO TO MY FRIEND _____.

SHE IS REALLY _____
(ADJ.)

AND ALWAYS _____

TO CHEER ME UP.

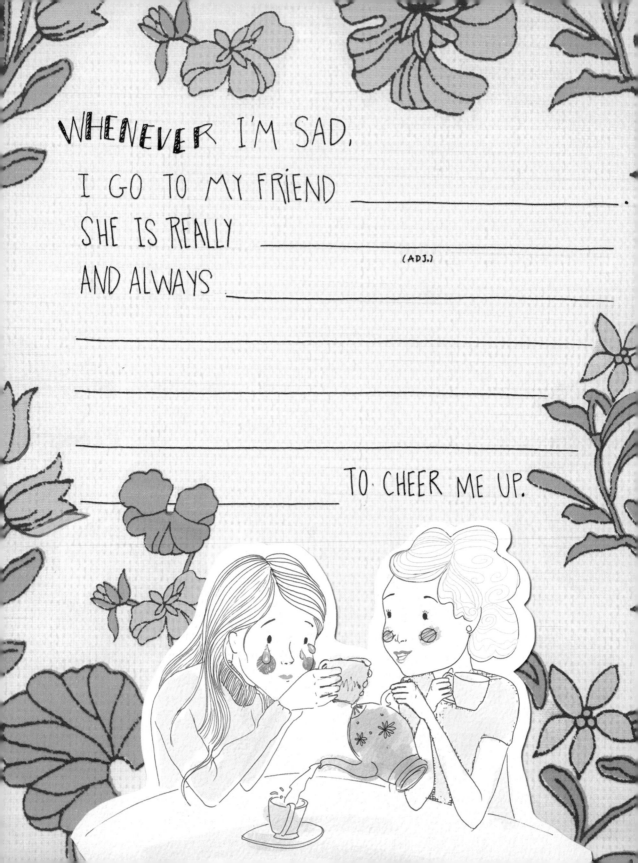

IF SOMEONE IS *Lying* TO YOU BUT THEY REALLY BELIEVE WHAT THEY'RE SAYING, ARE THEY STILL *Lying*?

☆☆☆☆☆☆☆☆☆☆

THIS IS A SERIOUS DEBATE I'M HAVING WITH MYSELF

VS.

_____ _____

[SOMETHING DUMB] [SOMETHING POTENTIALLY MORE OR LESS DUMB]

PROS
OF EACH

CONS
OF EACH

AS YOU CAN SEE, IT WAS A BIT OF A STRUGGLE, BUT _____ CAME OUT ON TOP.

☆☆☆☆☆☆☆☆☆☆

Date:

Dear _____,

I wanted to let you know that you make me laugh harder than anyone else on this dear planet Earth.

Yours,

OUT.

My friendship with _____ is like

_____ _____ because...
(gerund) (geographic noun)

(Please expound at any length using many nouns and adjectives and even verbs.)

I spend every day with **my** fire-breathing dragon, pepper flying to exotic lands. I do my homework on the way so it's really no big deal if you ask me, mom. I go to buy my **favorite** cupcakes in London and to visit my secret boyfriend the prince. He tries to shower me with gifts, but I'm a strong, independent, beautiful world traveler that can't be bought or carry many things on the back of her dragon in flight. I do bring back **things** I find in countries I've never been to before to relive memories because they're worth schlepping. Sometimes I write entries **to read** later on so I don't forget all the things I did or that happened to me, also I need them for the memoir I'll be writing in 50 years. As for **RIGHT NOW** I'm late for dinner and mom made my favorite, but in all honesty deserts rock my world and my favorites **are**: creme brulee, cookies (dur), ice-cream, mangoes, mushrooms and frosting from the tub will suffice as a meal from time to time. I can recall a bout ten times.

1.

2.

3.

4.

5.

6.

7.

8.

9.

10.

or if I should bring pepper to school from time to time. I might need her as she will make the day better, but she needs her rest and I need to focus if I ever want to be a grownup.

HERE IS A SKETCH OF
THE HOUSE I WANT
TO LIVE IN ONE DAY.
AND HERE IS MY PET SHARK, RITA.
HE LIVES HERE TOO.

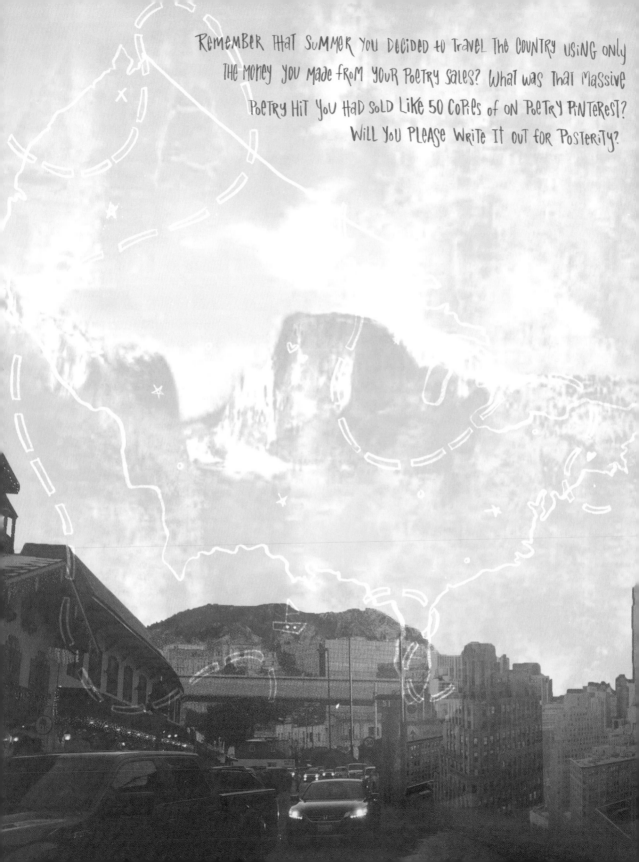

REMEMBER THAT SUMMER YOU DECIDED TO TRAVEL THE COUNTRY USING ONLY THE MONEY YOU MADE FROM YOUR POETRY SALES? WHAT WAS THAT MASSIVE POETRY HIT YOU HAD SOLD LIKE 50 COPIES OF ON POETRY PINTEREST? WILL YOU PLEASE WRITE IT OUT FOR POSTERITY?

I'M ALWAYS GOOFING OFF _____. SHE'S JUST SO

WITH _____ and

I THINK SHE'S HIGH-LARIOUS BECAUSE _____

_____ .

"Now in a moment I know what I am for
—I awake."

—"A World out of the Sea," Walt Whitman

What wakes you up, sunshine?

Here is the most recent thing
I got in the mail that was actually
addressed to me.

YOUNG
COLLECTOR

Pictorial
STAMP MAP of the
with FREE STAMPS

. S. HAMMOND & CO.
Suite 1
517 Valley Street
Maplewood, New Jersey

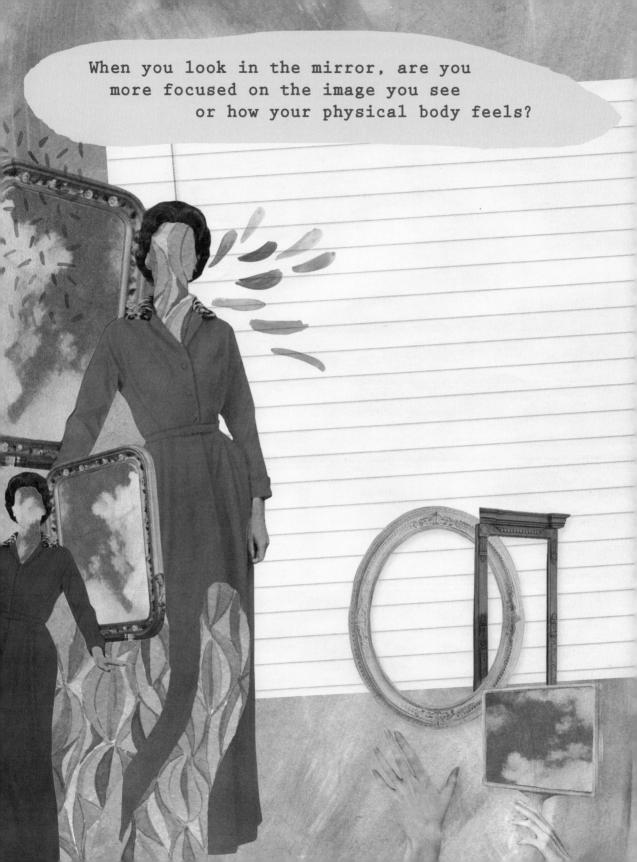

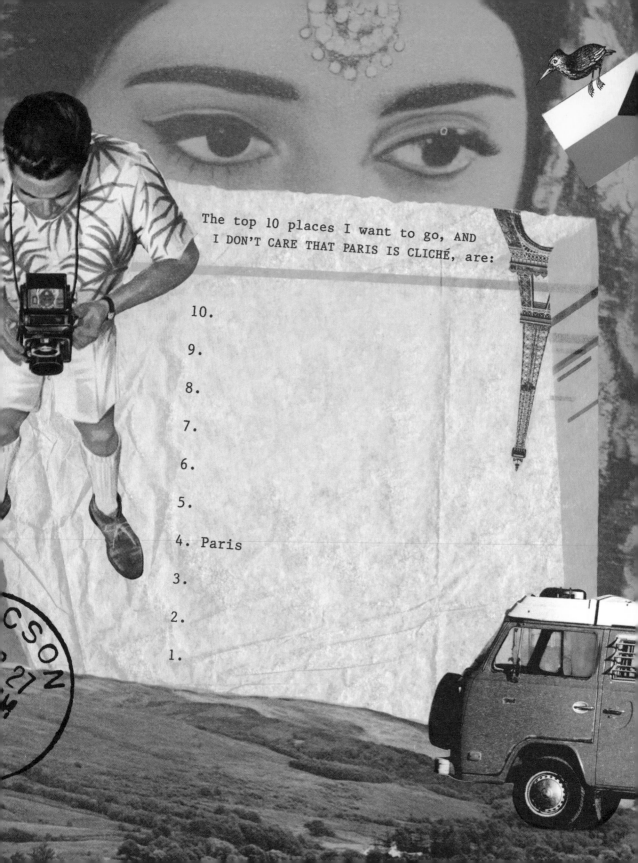

The top 10 places I want to go, AND
I DON'T CARE THAT PARIS IS CLICHÉ, are:

10.

9.

8.

7.

6.

5.

4. Paris

3.

2.

1.

DatE :

DeaR _____,

I'M So SoRRy ABouT...

YouRs,

The friend I've had the LONGEST is _____.
We met when _____

and we became friends because _____

_____ and that is the story of that.

MY GO-TO HAIRSTYLE is _____.

IT'S JUST SO _____ AND
(ADJ.)

_____ AND it TAKES
(ADJ.)

_____ to DO. MY HAIR is
(TIME PERIOD)

(HOW DO YOU REALLY FEEL)

SO _____

_____ .

This is a roller coaster I designed for old ladies who just want to have fun sometimes. I plan to use it frequently down the road.

REMEMBER YOUR STINT
AS AN ACROBAT?
WHATEVER HAPPENED TO THAT HUNKY DUD
YOU PARTNERED WITH AND ALL OF THOSE LIONS? (BE SUF
TO INCLUDE THE BIT ABOUT THE TWO MISUNDERSTOOD
CLOWNS, THE MENACING STRONG MAN, AND YOUR
FEATHER BOA—MAKE IT UP IF YOU HAVE TO!)

"I am no bird; and no net ensnares me."
—*Jane Eyre*, Charlotte Brontë

MY CRUSH GAVE ME THIS _____

_____. I taped

IT HERE. IF THAT _____
(adj. meaning hot)

_____ EVER FINDS
(food or wild beast)

I WILL DENY THAT THIS IS MY
JOURNAL

4347

DO YOU THINK *LOVE* IS SOMETHING THAT *We Do* OR SOMETHING THAT *Happens* TO US?

THings that work for Me:

1.
2.
3.
4.
5.
6.

THINGS that <u>doN'T</u> WORK foR Me:

1.
2.
3.
4. MULTiple CHoice QuiZZes (NO ONE THiNG DEFiNes ME!)
5.
6.

DATE: _____

DEAR _____,

I don't like you at all.

TO:

DO NOT SEND

I'M ALWAYS GETTING INTO TROUBLE
WITH MY FRIEND _____

BECAUSE...

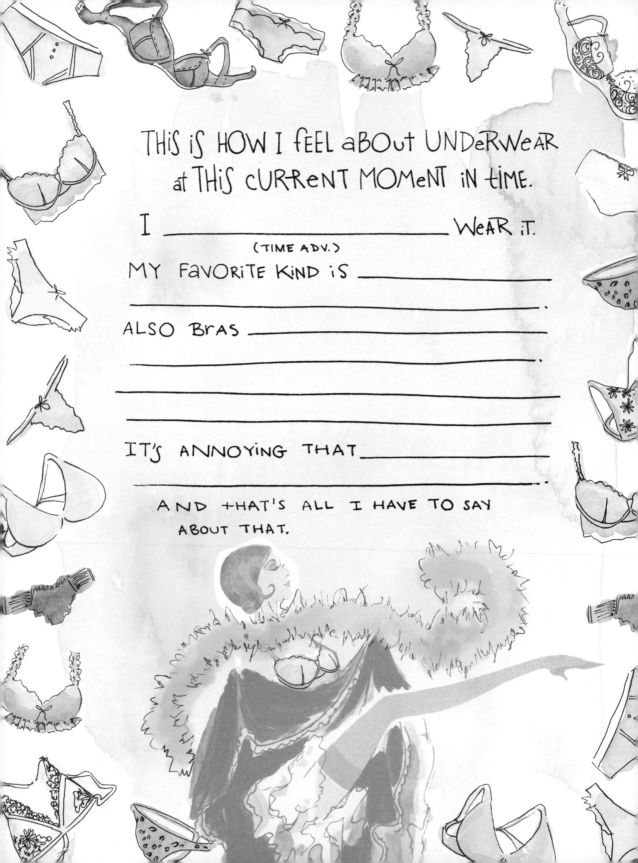

THiS iS HOW I FEEL aBOut UNDeRWeAR
at THiS CuRReNT MOMeNT iN time.

I _____ WeAR iT.
 (TIME ADV.)

MY FaVORite KiND iS _____
_____.

ALSO BRaS _____
_____.

IT'S ANNOYiNG THAT_____
_____.

A N D +HAT'S ALL I HAVE TO SAY
ABOUT THAT.

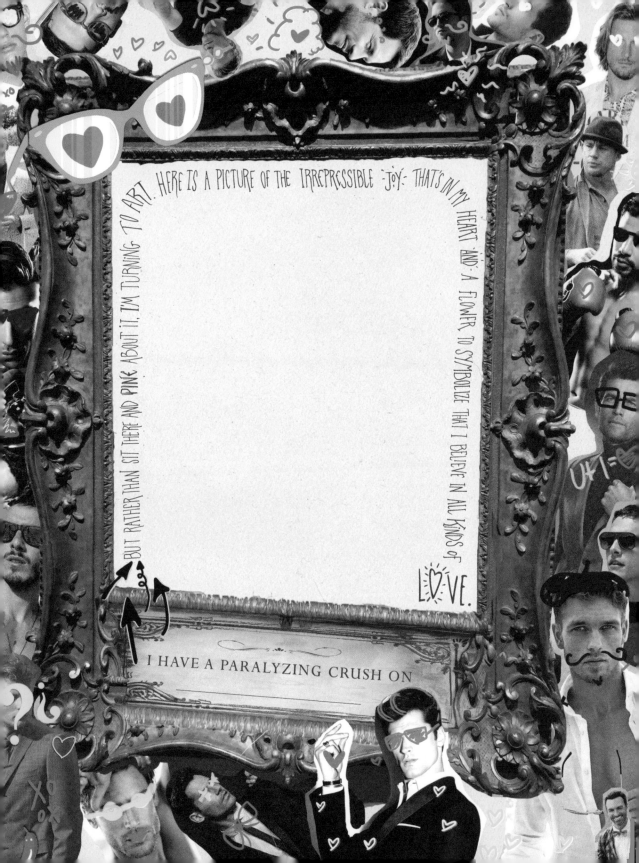

HERE IS A PICTURE OF THE IRREPRESSIBLE ·JOY· THAT'S IN MY HEART ·AND· A FLOWER TO SYMBOLIZE THAT I BELIEVE IN ALL KINDS OF LOVE.

BUT RATHER THAN SIT THERE AND PINE ABOUT IT, I'M TURNING TO ART.

I HAVE A PARALYZING CRUSH ON

OH. Baby. Remember that time you went to a DANCE CLUB?
And they started playing that song—what was it?—
and you got up on stage because
YOU HAVE NO SHAME IN YOUR GAME?
(Please do remind us of the song, and your
exact sequence of moves, and also what else
you were wearing besides a crop top—
make it up if you have to!)

WHEN I'M AROUND MY FRIEND ~~~~~~~~~~~~~~~,
I FEEL MOST LIKE THE VERSION OF MYSELF THAT COULD
KICK a$$ BECAUSE...

"A very little key will open a very heavy door."
—*Hunted Down*, Charles Dickens

HERE IS THE LABEL FROM THE LAST BEVERAGE I DRANK OUT OF A BOTTLE AND ALSO A HEART THAT I DREW FREEHAND, BECAUSE IT'S GOOD TO HYDRATE.

WHEN IS IT BRAVER TO TAKE A STAND,

AND WHEN IS IT BETTER TO WALK AWAY?

10.

9.

8.

7.

6.

5.

4.

3.

2.

1.

← THE

10

MOVIES / TV

SHOWS that

HAVE MOST

INFLUENCE

MY LIFE ARE

←

DATE:
DEAR _____,
I MAY NOT ACT LIKE
IT ALL THE TIME,
BUT I ACTUALLY
THINK YOU...

YOURS,

People are always SURPRISED to find out
_____ and I are so close. I guess it's because
we're _____ . The TRUTH is, though, _____

If I had
One Book
-&-
One CD
on an Island
to read and listen to over and
over again
They Would Be

& _____

Because...

This is a box of flowers I know how to draw because I've doodled them on EVERY paper I've had since second grade. okay, fine, that one's a puppy. Oops.

That was a weird one.

(Please do remind us of what was going through your head, and how you dealt with, you know, the miracle of birth, and also how you spared your awesome shoes from coming to harm—make it up if you have to!)

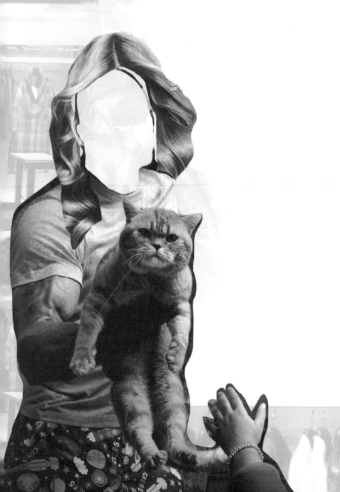

This is a photo of me and my pals.

We love one another even though half our eyes are closed.

"Be happy.
It's one way of being wise."

—Colette

My favorite fictional friendship is between

_____ and _____

from the _____
 (type of media)

_____ .
 Title

I love them because...

NICE

KIND

GOOD

DO YOU THINK THERE'S
A DIFFERENCE BETWEEN
"BEING NICE" AND
"BEING KIND" AND
"BEING GOOD"?

CAN YOU BE ONE AND NOT THE OTHERS?
(YOU MIGHT WANT TO INCLUDE
A VENN DIAGRAM. JUST SAYING.)

THE WOMEN I ADMIRE MOST ARE:

5.

4.

3.

2.

1.

DATE:

DEAR _____,

I LOVE YOU DEARLY, BUT WILL YOU PLEASE RETURN MY
_____?

IT'S BEEN _____

AND I DO NEED IT FOR...

YOURS,